CREATURES

Of Greek Mythology

Coloring & Guide Book

Written & Illustrated By Davina J. Rush

This book is intended to provide general information and artistic entertainment. The author has researched the material presented here but does not claim to be an expert on the subject.

Some content in this book may not be suitable for children. Parents are advised to read and look over the material presented here before sharing this book with their children. The author has created this book with a more mature audience in mind (ages 10 to adult). The contents are not purposely inappropriate, but they are written and drawn according to Greek mythology which was known to have suggestive and violent content. The author has taken care to censor the use of certain words and suggestive material as much as possible without completely compromising her artistic style or the facts of the myths presented.

As with everything that I do in life,

this book is dedicated to

my two greatest loves,

My daughters,

Hailey and Melina

Also dedicated to those special people who are always so supportive and encouraging of my artistic endeavors.

To my sister Patricia, my father David, my mother Brenda and step-father Richard for listening with special interest to my ideas on this project and cheering me on every step of the way! Also to my grandparents and all the rest of my friends and family for always supporting my dreams and believing in me and everything that I do. Thank you all for being such an amazing part of my life!

A special thanks to Brandy, for guiding me into the publishing world, I am ever grateful for your inspiration.

Content

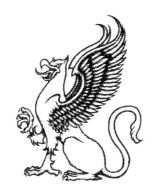

In the beginning there existed only Chaos; a boundless, darkened void full of infinite possibilities. From the primeval womb of Chaos the goddess Gaia (Earth) was born; the eternal foundation and home for all life to come. After Gaia's birth, Chaos also bore Tartaros (The Underworld), and Eros (God of Love). From these three entities our newborn world sprang forth with sky, ocean, night and day, mountains, valleys and... The Gods.

The first of the gods were the Titans; the main ones were Hyperion, Coeus, Oceanus, Crius, Cronus, Iapetus, Mnemosyne, Phoebe, Rhea Tethys, Theia, and Themis. These twelve formidable deities were the first generation of gods; the elders of all future supreme beings in Greek belief. The Titans soon bore six children of their own, creating a new generation of gods and goddesses. However, fate did not smile on the Titans as they were doomed with the birth of these children.

The offspring of the Titans, The Olympians, violently overthrew their parents and imprisoned them within the black, depths of Tartaros. With the old ones conquered, the Olympians would now reign supreme on Mount Olympus as the high-ruling gods and goddesses over all of creation.

There were six Olympians; Zeus, Hera, Poseidon, Hades, Hestia and Demeter. These power-loving gods would not stop at having taken over the rule of all things; their ambitious desires had not yet been filled. Zeus, who had taken the highest position above all the gods, wanted more creatures to serve and to worship him. With this desire he ordered Prometheus (one Titan who he had not banished with the others) to create man upon the Earth. Prometheus did this, and in his task he also gave man a small spark from the sacred fires of Olympus. With this act of generosity he greatly angered the high god Zeus and incurred his great and unyielding wrath. Zeus ordered that the Titan Prometheus be chained forever to a mountain and endlessly tortured by the bewitching and sensual woman, Pandora.

The creation of man was not the end of the Olympian's blossoming realm. The gods grew and expanded even further with children of their own, creating future generations of divine beings. They married among themselves, and elsewhere, creating offspring of varying ranks and forms. Zeus and Hera would have fully divine children together such as

Ares, Hebe, Hephaestus and Eileithyia. Then there were instances where a god or goddess would have children with a mortal such as Zeus and the woman Alcmene who bore the demi-god Hercules. There were also more perverse occurrences where gods such as Earth or Ocean would couple and a fearsome creature would be born such as Echidna, who was half woman and half snake, born of Tartaros and Gaia.

The generation of creatures began with one but they soon became many, filling up man's world and minds with their malevolent presence. Stories traveled far and wide over years and centuries keeping the terror of these dark creatures alive within the deadly face of Medusa, the piercing bite of Cerberus and the bitter claws of the Harpies. Each creature was a monstrosity, well-deserving of both fear and respect. They were both beautiful and fearsome all at once. Each one a dark and yet divine being; a child of Chaos!

Note: For best results high quality coloring pencils or pens are recommended for coloring in this book. If you are using pens or markers then please take care to place a sheet of paper under the picture that you are working on to prevent bleeding (extra pages has been provided in the back for this). Additionally, if you choose to use anything other than color pencils, you may choose to color only the pictures in the image cache (starting on page 43) while preserving the guide section of the book.

CREATURES

Of Greek Mythology

Coloring & Guide Book

Written & Illustrated By Davina J. Rush

Echidna

(Pronounced Eh-kid-nuh)

Echidna was known as "the mother of all monsters" since she bore many of the darkest and most well-known creatures in Greek mythology; Cerberus, the Chimera and Ladon are just a few of the fearsome beasts who call her mother.

Echidna's parentage has been the subject of much debate. One story claims that she was the child of Tartaros and Gaia (the underworld and Earth); while another story claims her parents were Ceto (a sea goddess) and Phorcys (a sea god). There are many other possible matches as well. Which one is correct? Who knows!

In the Greek language, the name Echidna literally means "she-viper"; name that fits this fearsome creature quite well as she was born with the upper torso of a woman and the lower body of a terrifying serpent.

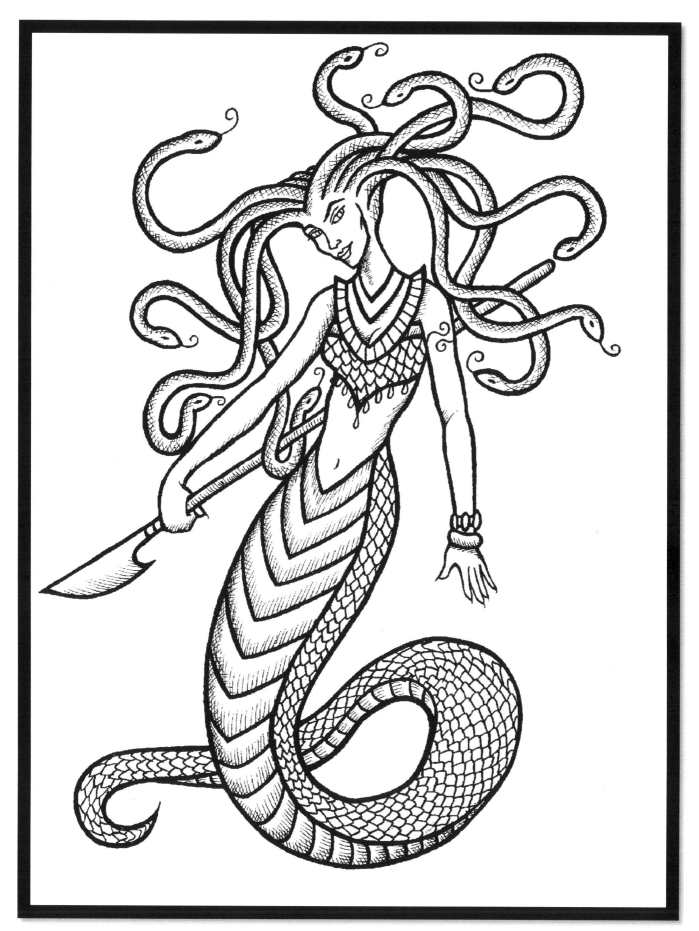

Typhon

(Pronounced Tī - fon)

Typhon, Echidna's husband, was known as the "Father of all monsters". A fearsome beast feared above all others; Typhon was described as having a human upper body while his lower body was the giant coils of snakes. With wings on his back and a hundred snake heads at the ends of each hand, Typhon had fire for eyes that could put fear into any living creature.

Typhon fathered many of the monsters in Greek mythology with his wife Echidna such as; the two-headed hound Orthrus, Cerberus, The Sphinx, The Hesperian dragon Ladon, The Hydra and Chimera etc. Together Typhon and Echidna were known as the parents of all monsters since they created the most malevolent and well-known creatures in Greek mythology.

The end of Typhon came when he battled and defeated the highest of the gods, Zeus. When Zeus was recovered he in turn defeated Typhon and imprisoned him forever beneath the great Mount Etna.

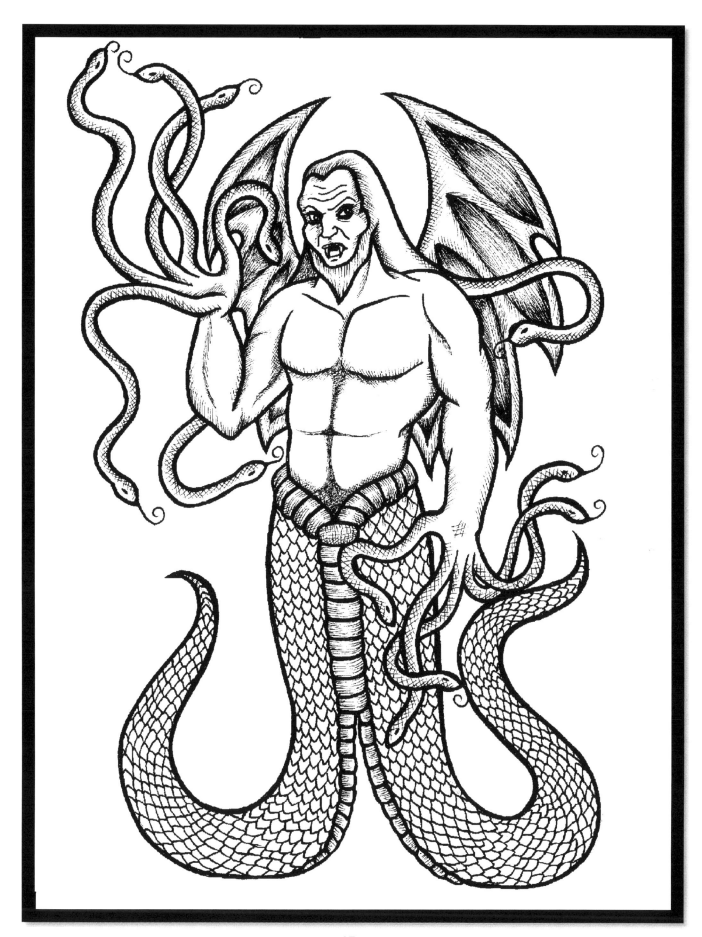

Medusa

(Pronounced Muh-doo-suh)

Medusa, meaning "guardian" or "protectress", was originally an enchanting and beautiful human maiden, a virgin priestess in Athena's temple. She was one of the three daughters of the sea gods Phorcys and Ceto. Medusa's beauty brought her many suitors but she refused all until she was violated by the sea god Poseidon.

Poseidon attacked Medusa within Athena's temple walls, which was a highly disrespectful act to the goddess; an act that enraged Athena. Angry at the blasphemy, Athena could not punish Poseidon but she transformed the victimized Medusa into a hideous Gorgon. Her once beautiful hair became writhing serpents; her face became that of death, so terrible to look upon that one glance into her lethal eyes would turn any mortal to stone.

Medusa was later slain, beheaded by the hero Perseus, who used her severed head as a lethal weapon in which to turn his enemies to stone.

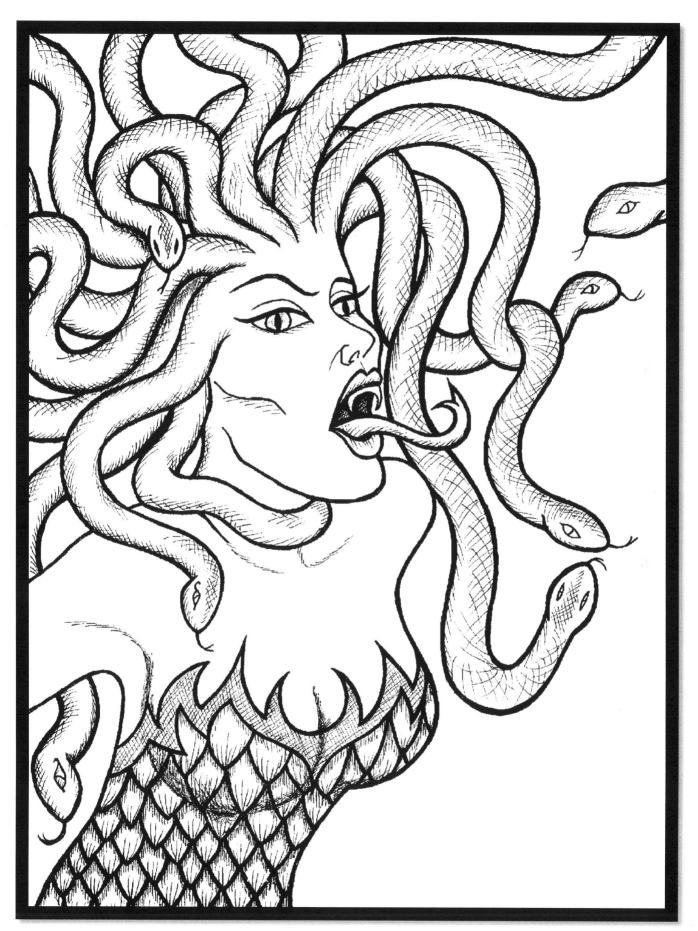

The Harpies

(Pronounced Har-peez)

In Latin, the word "harpy" means "snatcher"; a fitting name since the Harpies were known for their ability to snatch things up in their vulture-like clawed feet and fly away with ease.

The three harpies were sisters of the rainbow spirit, Iris, who was the messenger to the gods. They were daughters of the sea god Thaumas and of the Oceanid Electra. The three sister's names were Aello, Celaeno and Ocypete.

The Harpies were described as ugly and vicious bird-women with beak-like faces, wings for arms, a human torso and bird-like legs and claws. They lived on Strophades and were known as spirits of punishment; they snatched up those who were deserving of their wrath without warning and tortured them relentlessly on their way to the underworld.

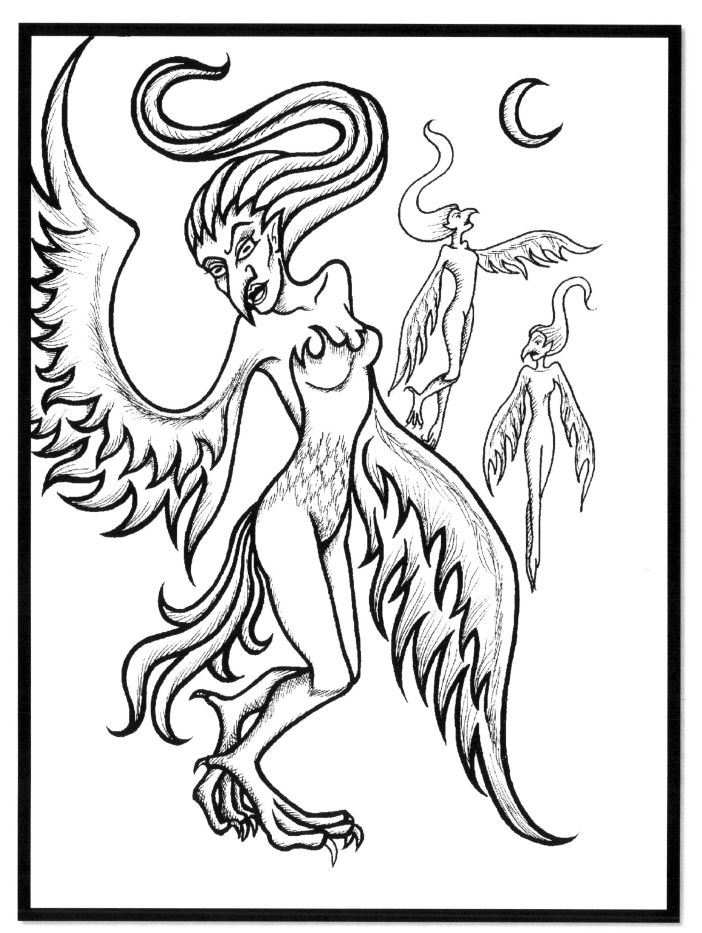

Cerberus

(Pronounced Sur-bur-us)

In Greek mythology, Cerberus (or Kerberos) is a three-headed hound who guards the gates of Hades. He stands ever-vigil at the entrance to prevent those who are doomed to the underworld from ever escaping back into the world of the living.

Cerberus was born of Echidna, "the mother of all monsters". His father was a fire-breathing monster named Typhon, "the father of all monsters". His siblings were Orthrus, the Sphinx, the Chimera, the Hydra, the Nemean Lion, and Ladon. Both of Cerberus' parents and all of his siblings were the most vicious and fearful creatures in Greek Mythology.

Legend tells that the capture of Cerberus was the twelfth labor of Heracles (aka Hercules). The hero captured the three headed hound and took him to King Eurystheus as he was ordered. The king was terrified at the mere sight of the beast and so ordered that Heracles return the hound to Hades immediately and thus released him from his labors.

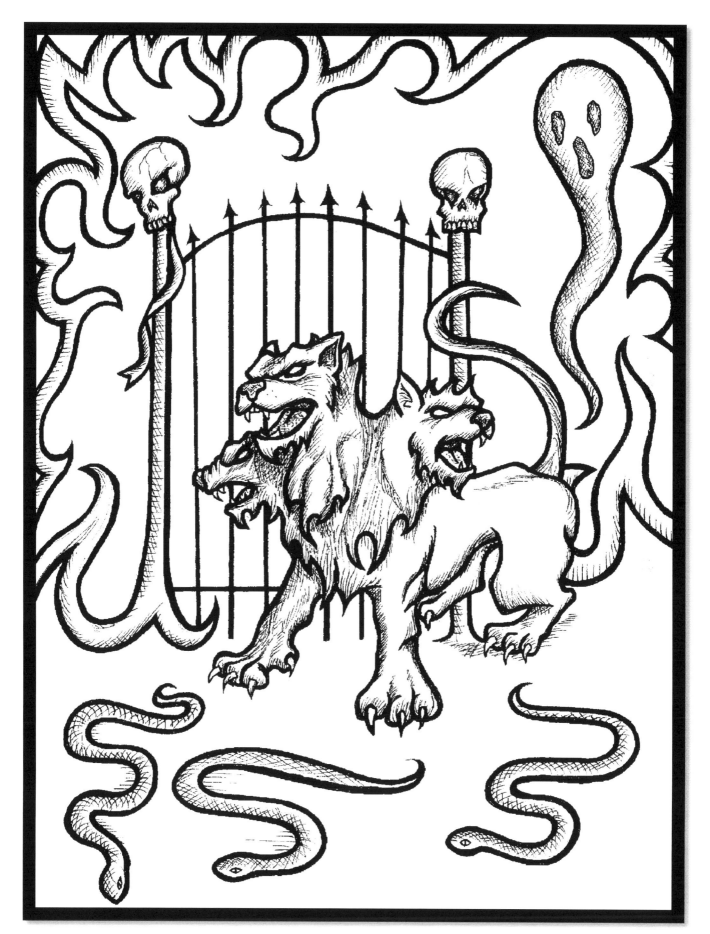

The Sphinx

(Pronounced Sfinks)

Unlike the male Egyptian sphinx, the Greek Sphinx is female. She has the body of a lion, wings of a great bird and the head and torso of a woman.

The Sphinx was known for guarding the entrance to Thebes and was also known for her obsession with riddles; a vicious and deadly obsession for any who participated. The Sphinx greatly enjoyed taunting trespassers with her most difficult of puzzles, feeling very sure that they could not answer correctly. Unfortunate for the mortal, when he could not answer correctly the Sphinx would eat him alive in one swift gulp! Oedipus was the hero who finally rid Thebes of the Sphinx by answering her riddle, "Which creature in the morning goes on four legs, at mid-day on two, and in the evening upon three, and the more legs it has, the weaker it be?". The answer to the riddle was simply "Man"; he crawls on all fours as a babe, and then walks on two feet as an adult, and then he walks on two feet, with a cane, in old age making "three" feet, and weaker with each.

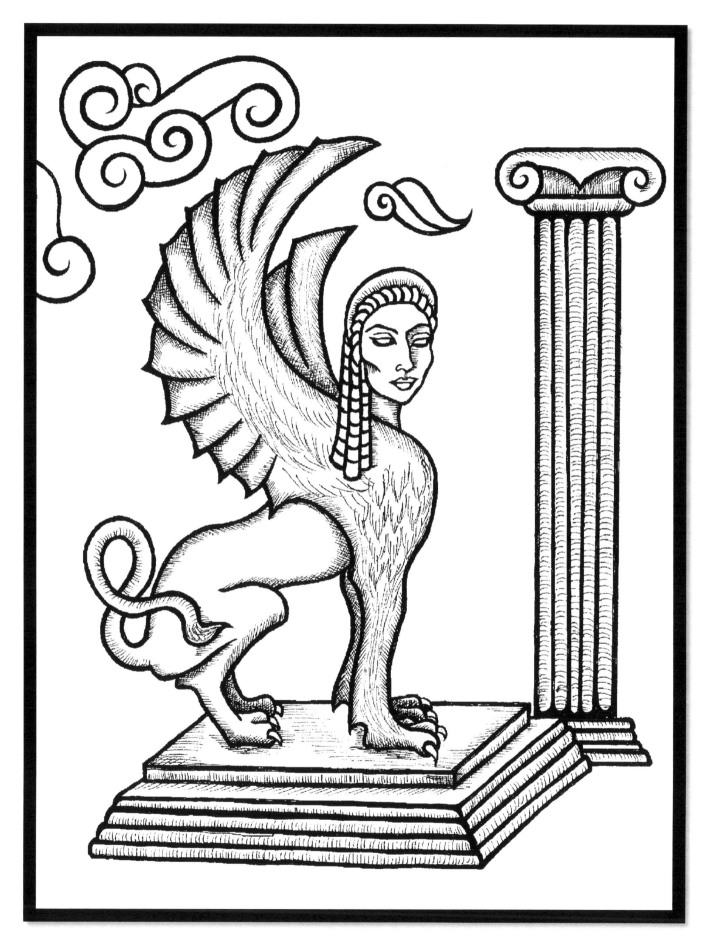

Hippocampus

(Pronounced Hip-ah-camp-us)

The Hippocampus, also called Hippocamp or Hippocampoi, is named from the Greek words meaning "horse" and "monster". It has been depicted in Greek mythology with the fore body being that of a horse and the hindquarter being scaled and fish-like. You might compare the Hippocamp to the sea-horse in some ways.

The Hippocamp was the horse of Poseidon, the great sea god. Poseidon is often illustrated in Greek art riding in a chariot drawn by many Hippocampi. You would often see these depictions in places that water was wished for or feared such as coastal temples, public baths and springs.

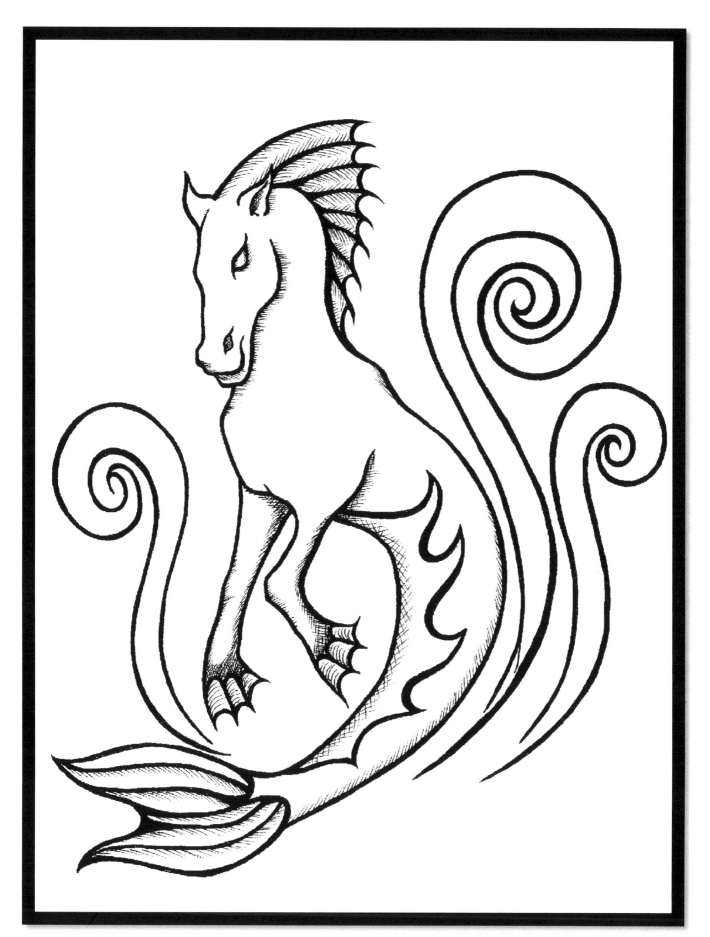

Griffin

(Pronounced Griff-in)

In Greek mythology the Griffin was depicted as a creature with the head and wings of an eagle, and the body of a lion. Its hind legs were that of a lion and the fore legs were the great talons of the eagle. These talons were believed to have the magical ability to heal, but they were also vicious weapons that could kill in one mighty swipe.

The legendary Griffin, being comprised from both the king of beasts (lion) and the king of birds (eagle) was a very powerful creature. It was said to be the guardian of divine treasures and of the gods themselves. The Griffin was also revered as a protector against evil; for this reason you might see statues of the Griffin standing guard in places of importance or portrayed on shields.

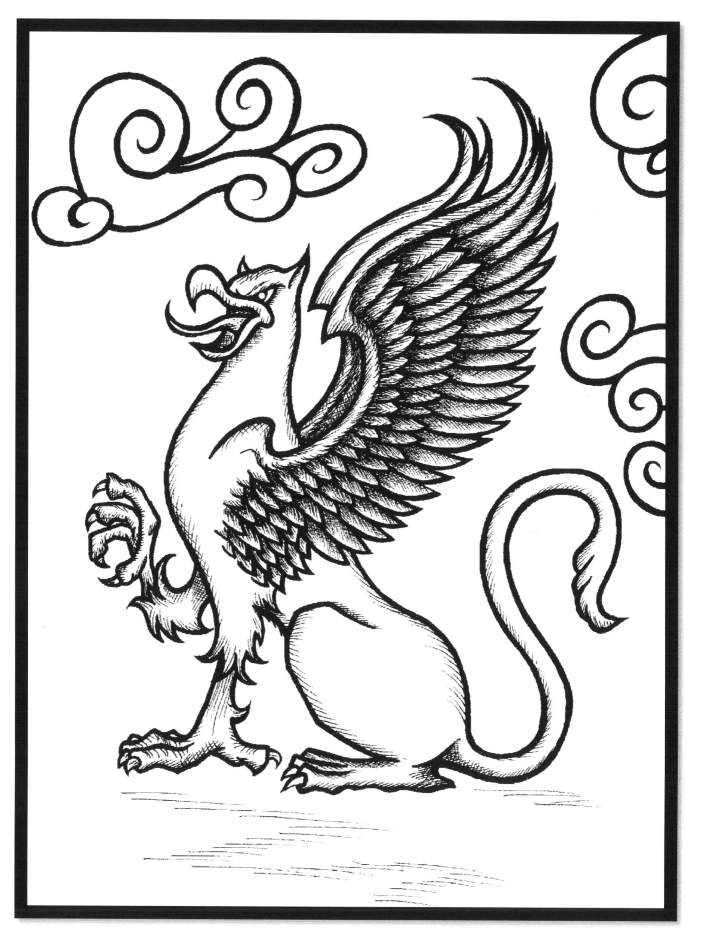

Pegasus

(Pronounced Peg-uh-sis)

Pegasus, the beautiful and enchanting white, winged horse of the gods. Pegasus was fathered by the sea god Poseidon, who is also god of horses. His mother was the terrifying Gorgon, Medusa. A child conceived while Medusa was still in her beautiful human form; before she was cursed as a terrifying Gorgon. Pegasus was born, along with his brother Chrysaor, from the blood of Medusa when she was beheaded by Perseus.

Pegasus, friend to the muses, was an inspiration within himself. Legend says that wherever Pegasus hooves struck the earth, a spring of inspiration would burst forth blessing all who drank its waters with poetic musings.

After many adventures on earth, Zeus brought this beautiful winged beast to the heavens as the constellation "Pegasus". There he has remained always as an ever-shining symbol of wisdom, poetry and heroic adventure.

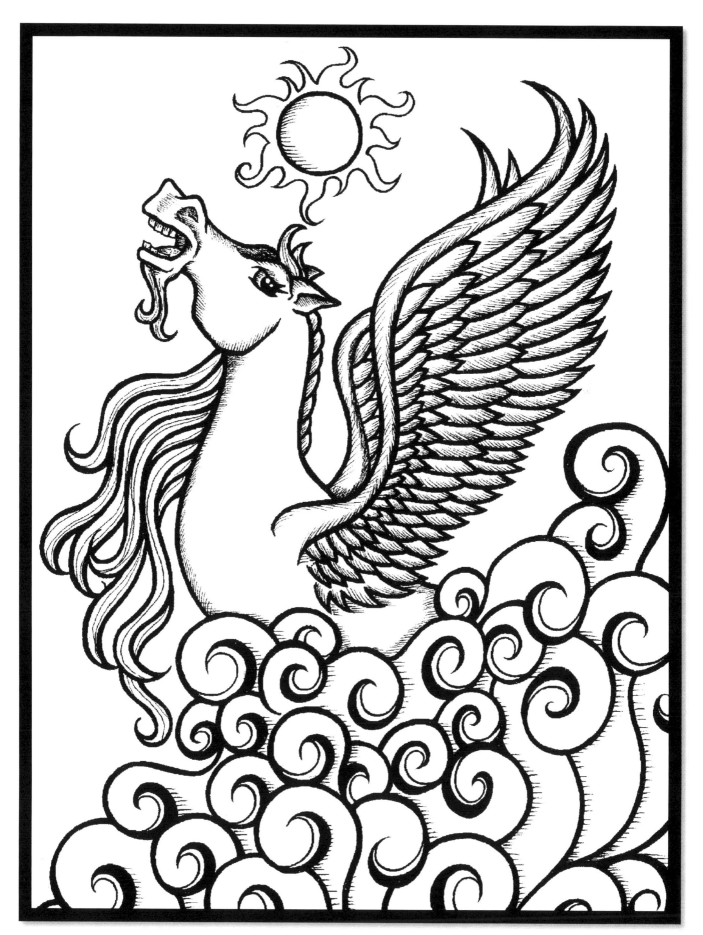

The Satyr

(Pronounced Say-tur)

Satyrs are the frolicking, pipe-playing companions of Pan, god of the wild. They were also friend to Dionysus, god of wine and merriment. The Satyrs were known for their love of wine, women and music. When Pan would play his pipes for the forest nymphs you could be sure that the Satyrs would come out to frolic and play right along with them, wine in hand and mischief always on the mind.

Satyrs are goat-like in appearance. Their upper body is that of a man but with a very hairy chest, arms and beard. Small horns sit atop his bushy head and his eyes are always alight with joy and mischief. The Satyr's lower body is the most goat-like of all his features as he has beastly legs with cloven hooves for feet.

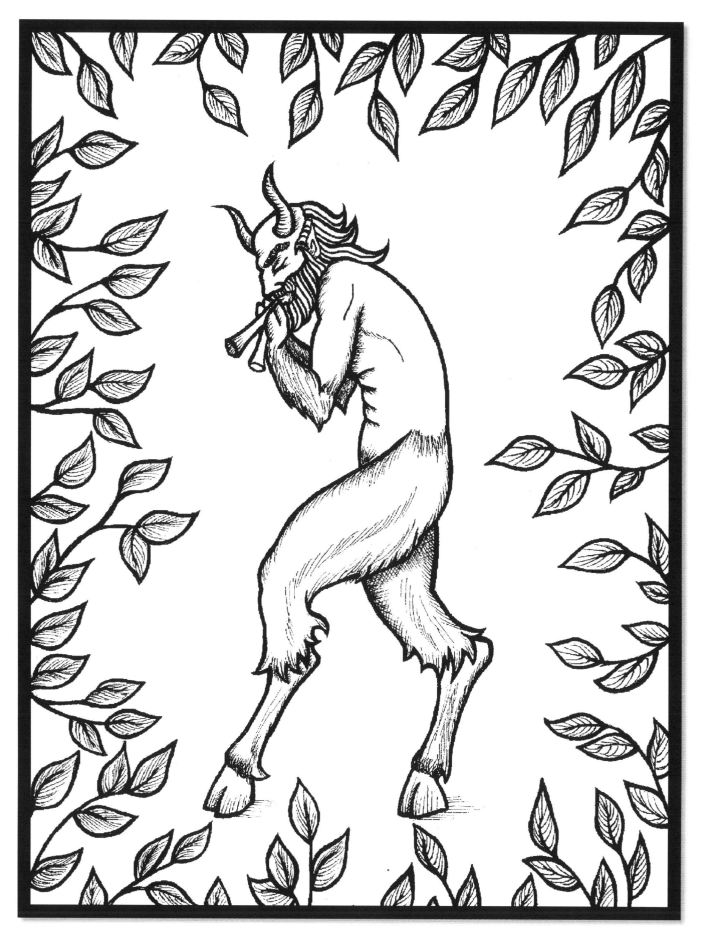

Centaurs

(Pronounced Sin-tar)

Part human and part horse, the Centaur is a well-known and interesting creature of Greek lore. Centaurs were followers of Dionysus, the god of wine, and they were known for their love of women and drink, much like the Satyrs. But, unlike the Satyrs, the Centaurs were not shy and where often said to kidnap young maidens in their drunken madness. They were known for their temper and wild nature.

The parentage of the Centaur race is described in two parts. It begins when King Ixion is tricked by Zeus into falling in love with a cloud that he had formed into the semblance of his wife Hera. Of this union a man was born, Centaurus. This man later coupled with the wild mares of Magnesia and the Centaur race was born.

The Centaurs now stand among many other Greek legends in the heavens above as the constellation called Centaurus; one of the largest constellations in the sky.

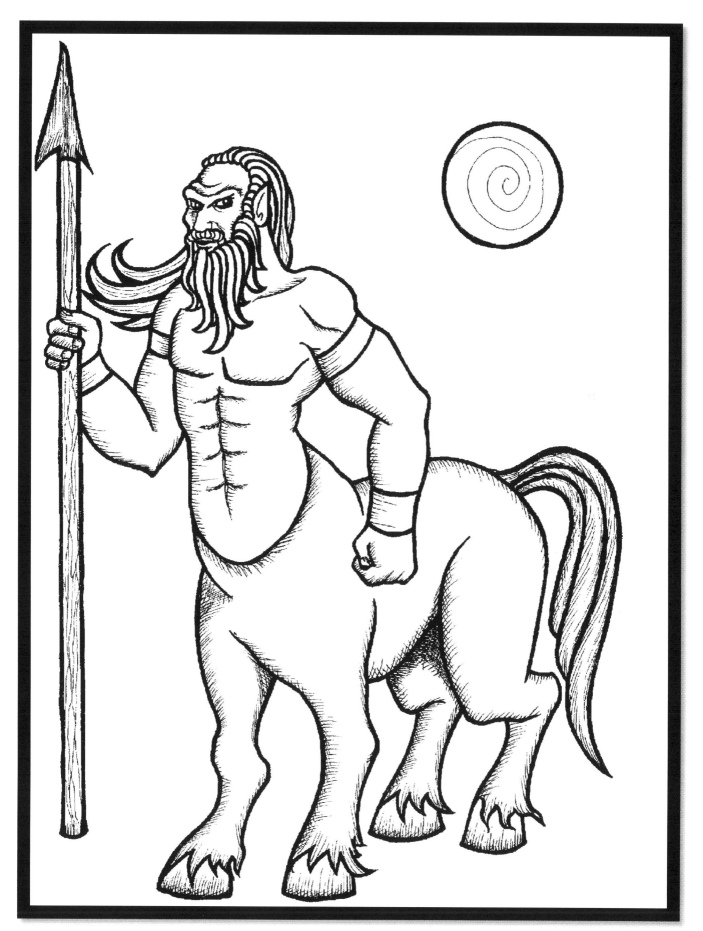

Cyclops

(Pronounced Sī-klops)

The Cyclops was a race of giants in ancient Greek mythology. There were a few races of giants but this one's distinguishing characteristic was that each giant only had one single eye in the center of their foreheads. These monstrosities were well known for their odd features, their strength *and* for their violent temper.

The poet Hesiod of Greek mythology wrote that the Cyclops were sons of Uranus (sky) and Gaia (earth). Uranus feared these sons of his and so he locked them up in Tartaros until they were later freed by Zeus. In return for his help, the Cyclopes giants helped Zeus and the Olympians to overthrow the Titans by creating thunderbolts that Zeus could use as weapons against them.

The Cyclopes were also known for having been the makers of Poseidon's trident, Artemis and Apollo's' bows and arrows, and Hades helmet.

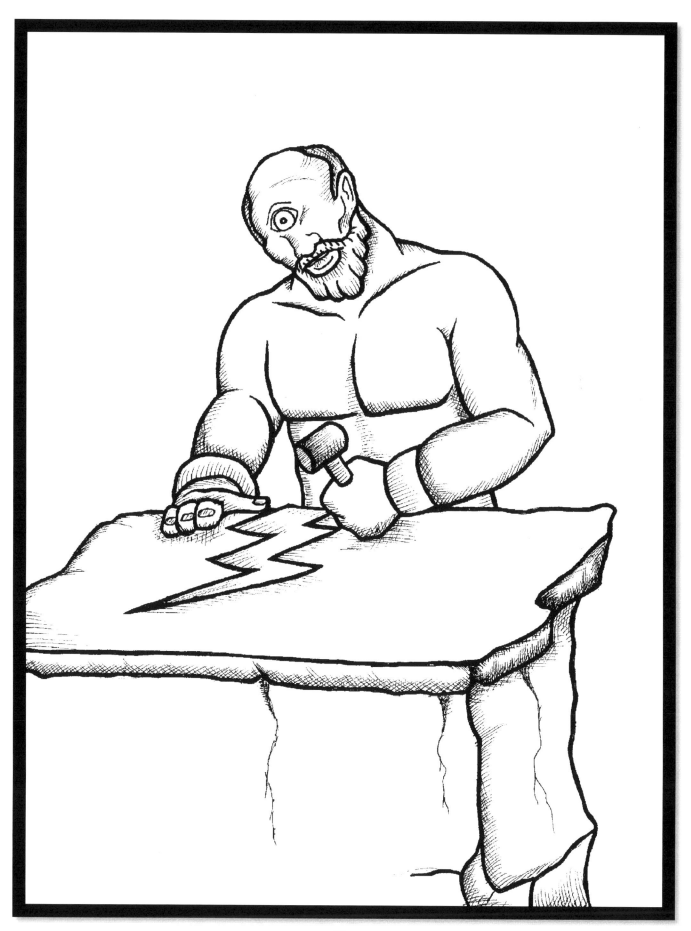

The Hydra

(Pronounced Hī – drah)

In Greek mythology, the Hydra was born of Echidna, "mother of all monsters", and of Typhon, "father of all monsters". It was described as a serpent-like beast with 100 heads. The Hydra is most often depicted in art with only three heads, for obvious reasons.

The Hydra was killed in the second "labor of Heracles" (aka Hercules), and this was no easy task! Because the Hydra emitted poisonous fumes in its breath; Heracles had to hold a cloth over his face and fight with only ONE HAND! Heracles hacked the beast's heads off, but this didn't help as each head that he removed would grow back as *two more*! It was Heracle's cousin who help him in finally defeating the hydra by burning each neck stump closed after the head was severed, so that it would not grow back.

Upon the Hydra's death, Hera raised the beast into the heavens as the constellation "Hydra", one of the top largest constellations.

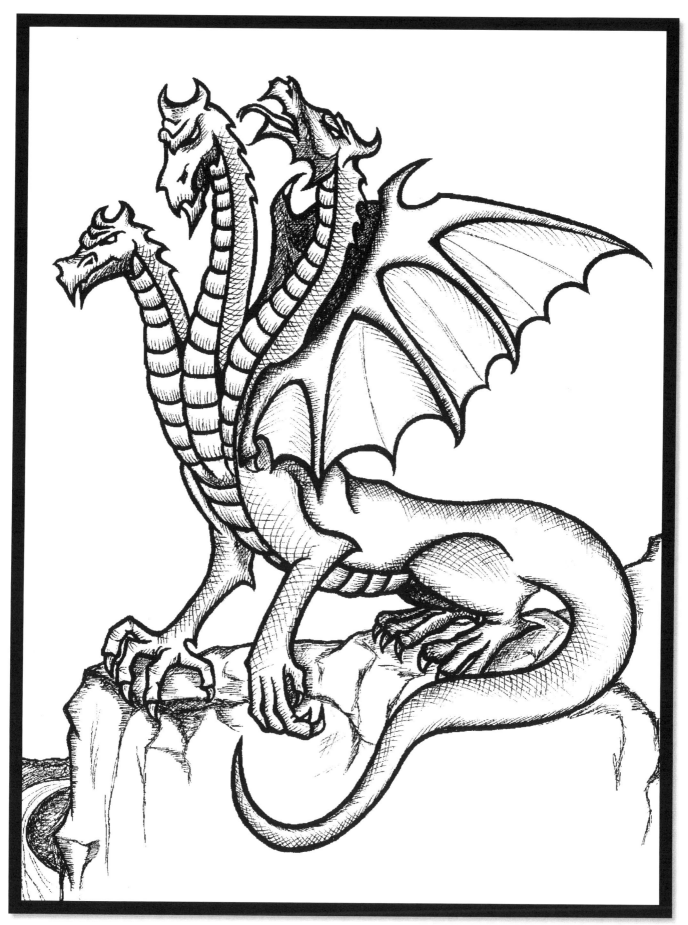

Note From The Author

I hope you have enjoyed your coloring and learning experience with the *Creatures of Greek Mythology* as much as I have enjoyed creating this publication. Your comments and reviews are greatly and sincerely appreciated.

For your added pleasure I have included an image cache, starting on page 43, which includes a second copy of every character in this book. With these bonus prints you may choose to leave the reference section of this book uncolored and only use the image cache prints, or you may choose to color every character twice. It's up to you!

Get more information on the author as well as updates on her latest publications, events, contests and more by visiting our official web page at:

Www.DavinaRush.com

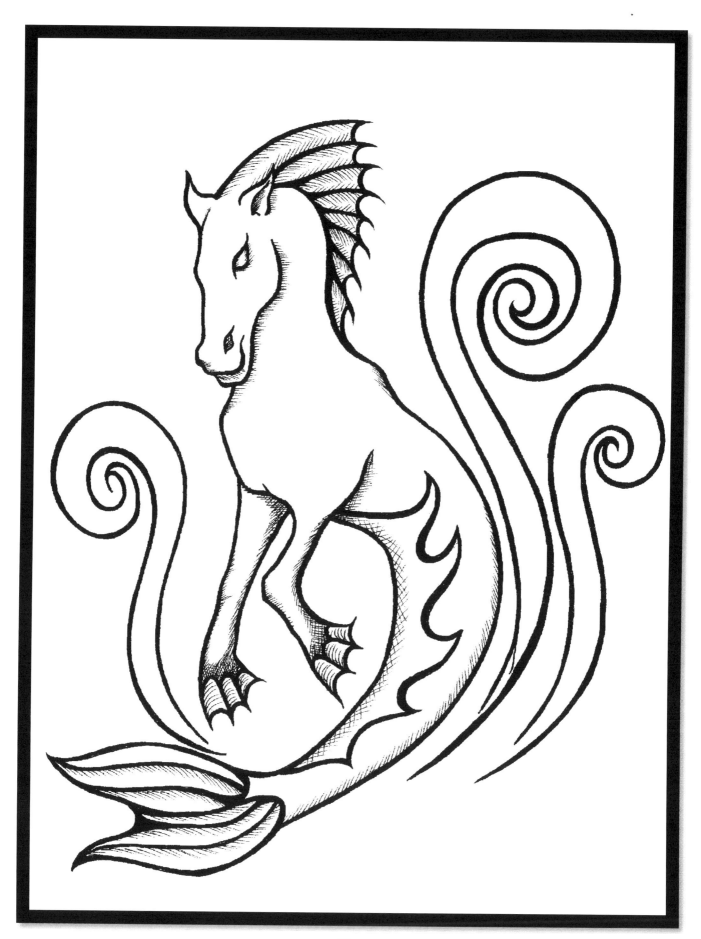

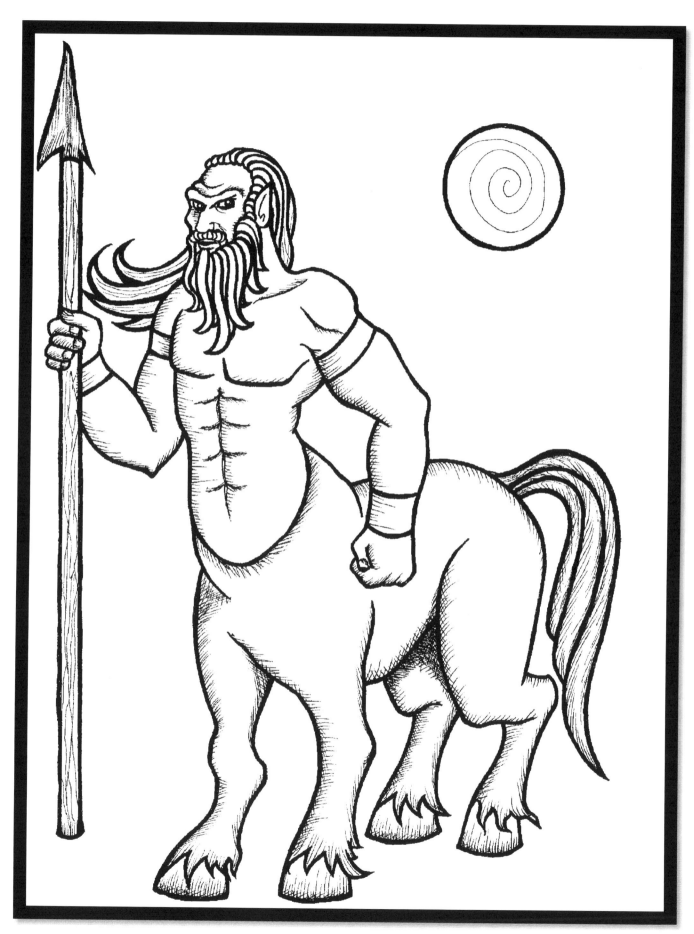

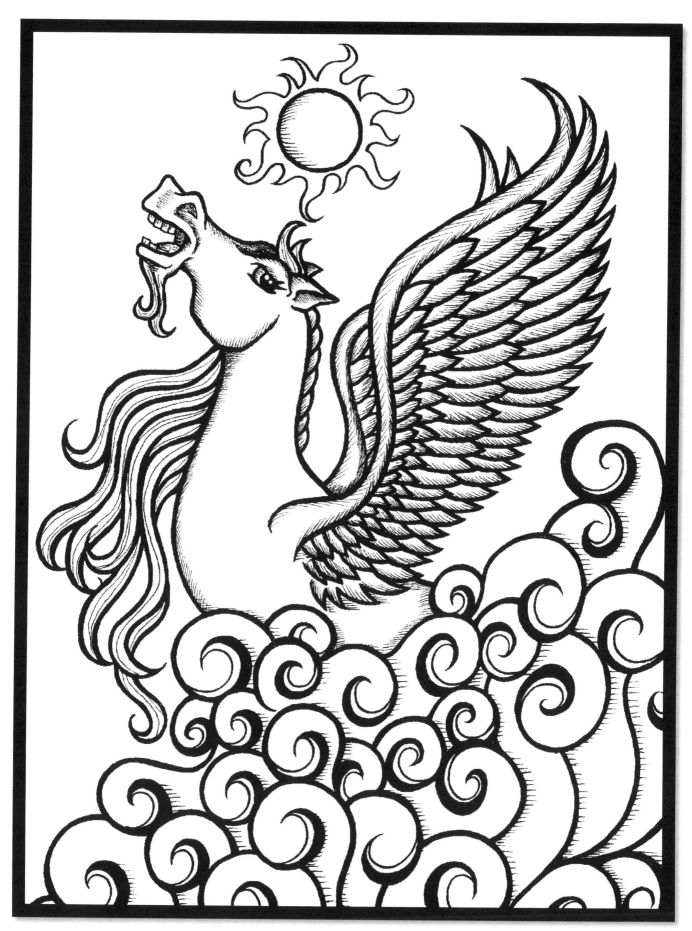

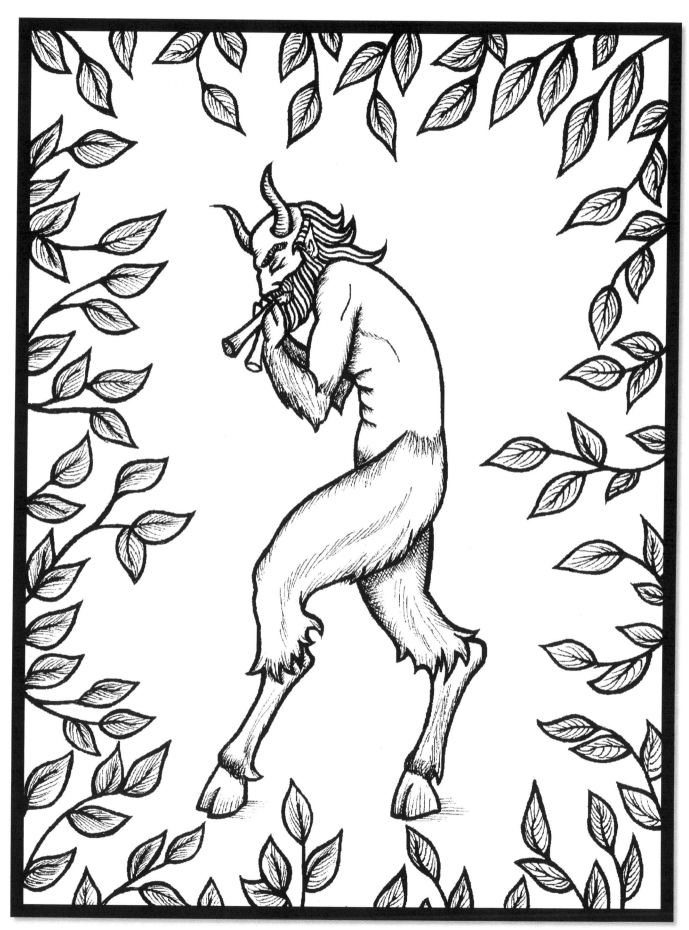

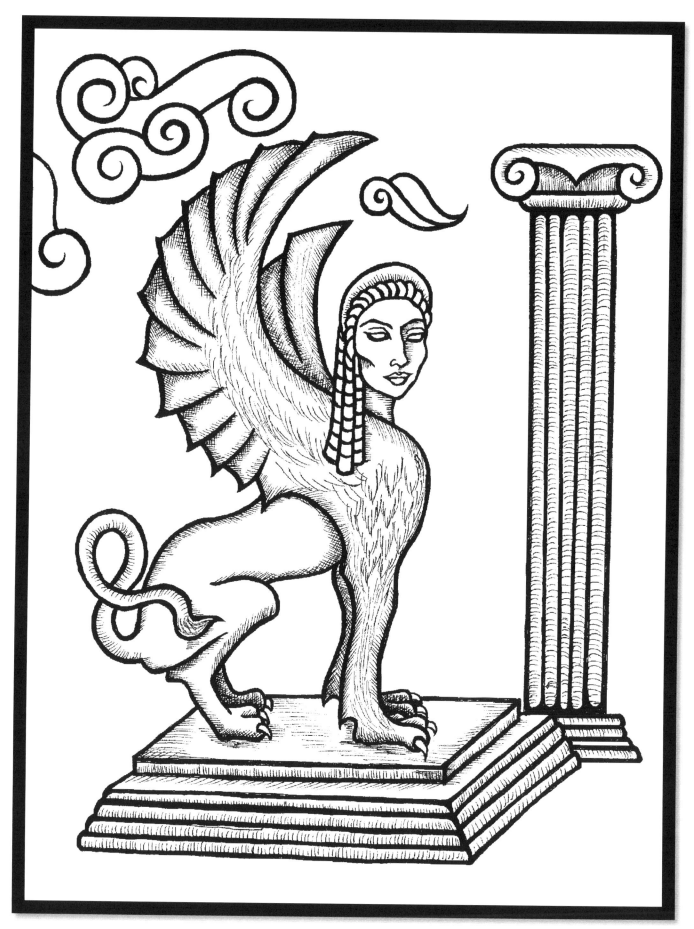

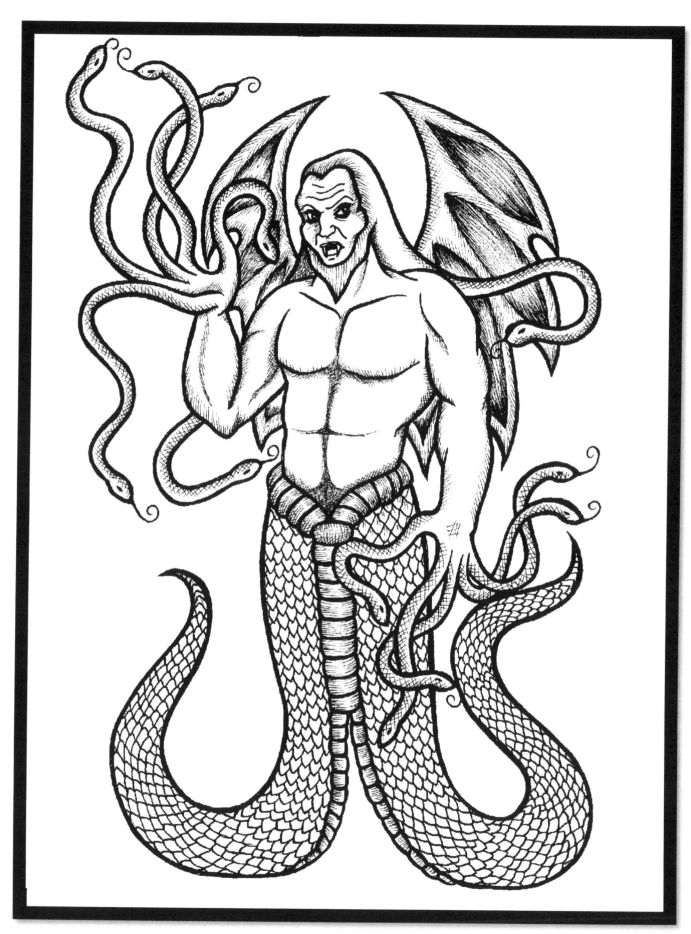

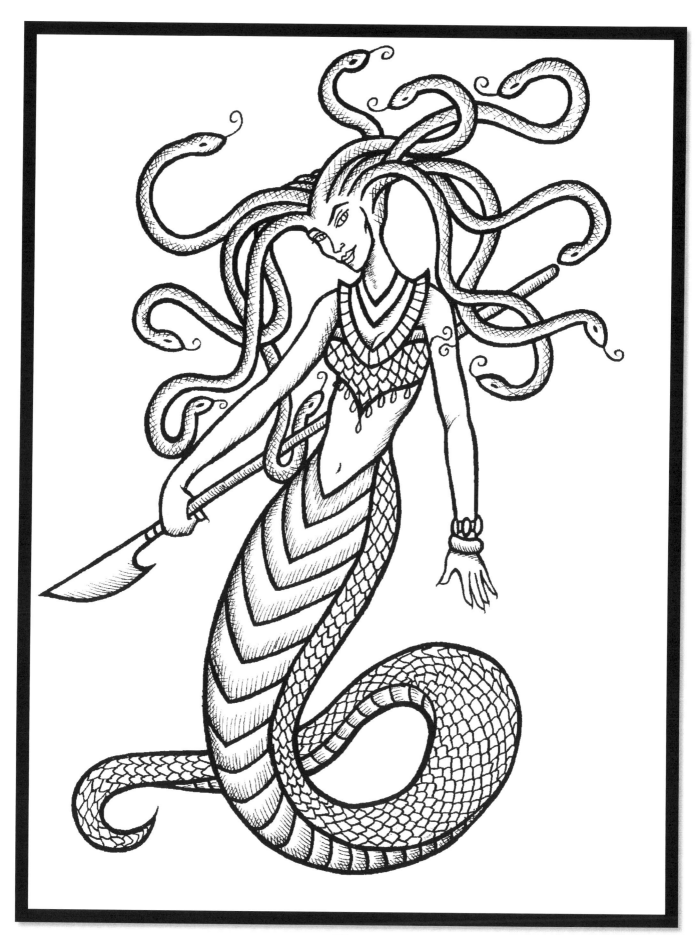

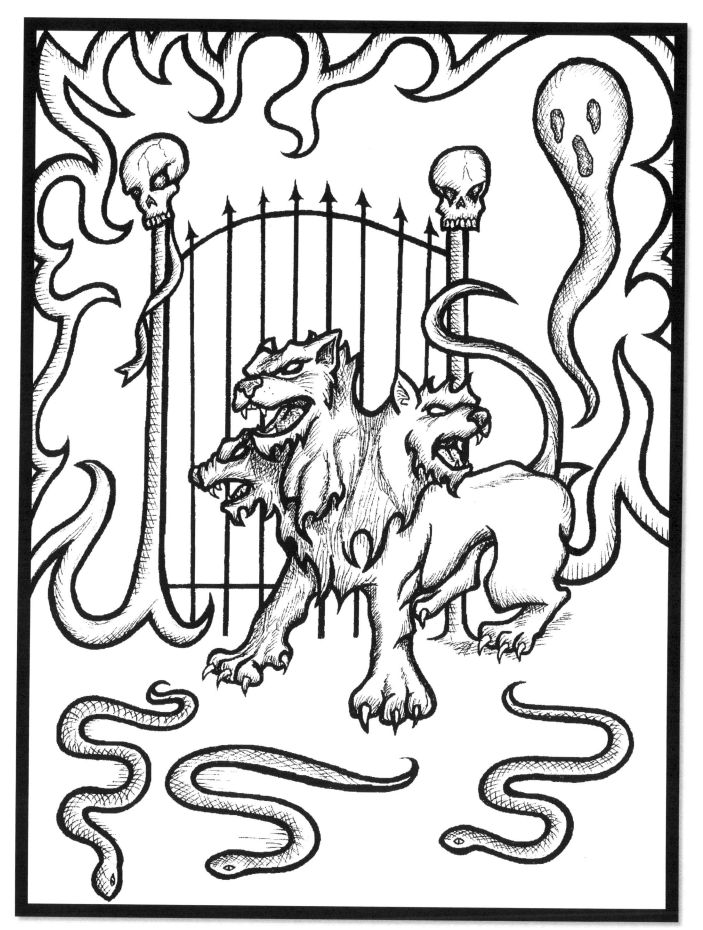

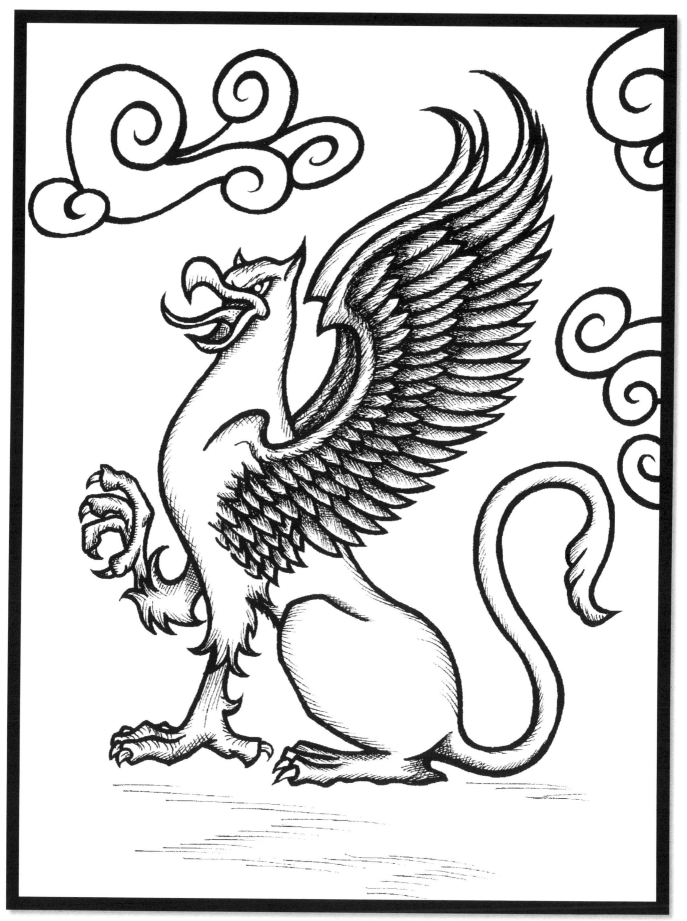

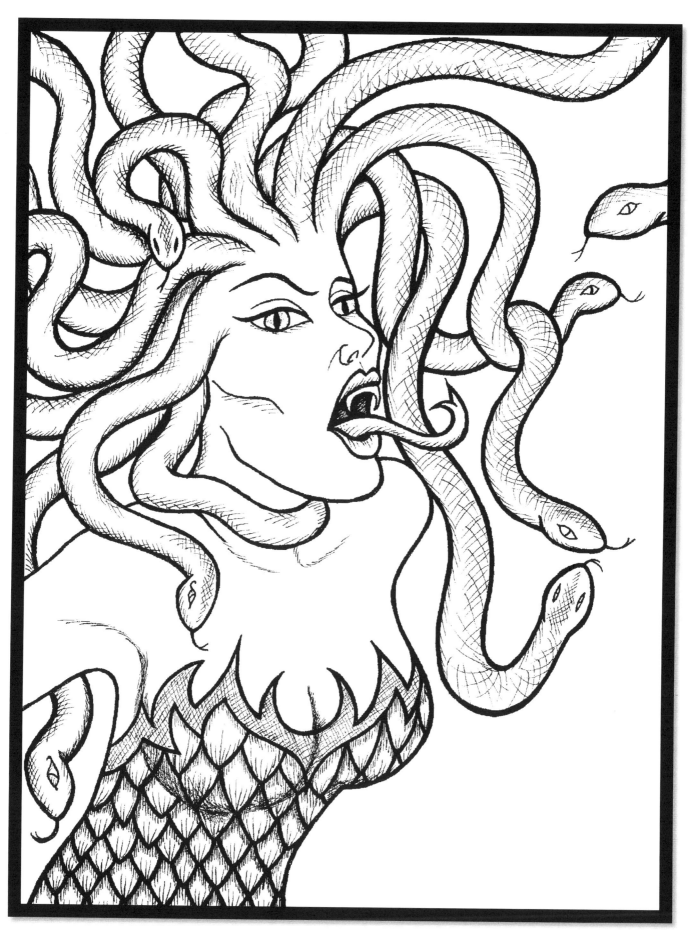

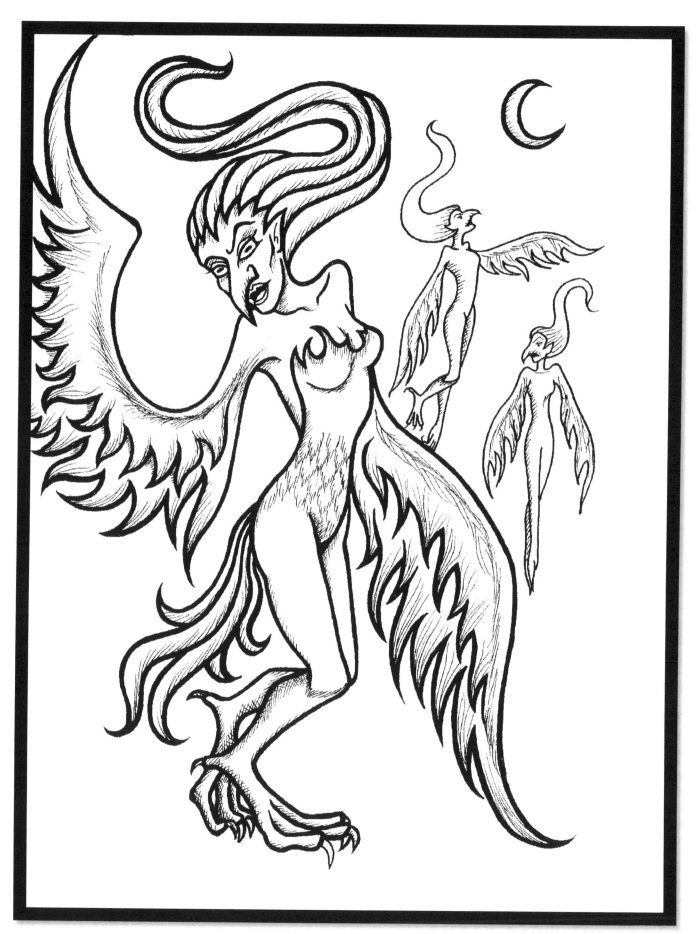

About The Author

Davina Rush is the author of many poems, short-stories, children's books, coloring/guide books and novels. Currently her publications include *Creatures of Greek Mythology;* her latest coloring and guide book *Creatures of Classic Horror* will be debuting in early 2013.

Davina was born in Northwest Florida on July 17th of 1978. She currently resides in Destin, Florida with her two daughters. Davina works to support her family as a single mother, while attending college for a degree in Art Education and pursuing her career as an artist and writer.

Read more about Davina, her publications, products, contests & events at

Www.DavinaRush.com

Keep up to date on Davina's latest publications, events,

Contests and news by adding us on Facebook and Twitter!

www.Facebook.com/ColoringBooksByDavina

www.Twitter.com/BooksByDavina

www.DavinaRush.Com

.

Made in the USA
San Bernardino, CA
25 April 2016